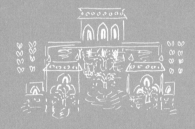
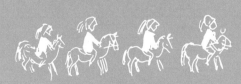
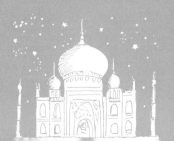

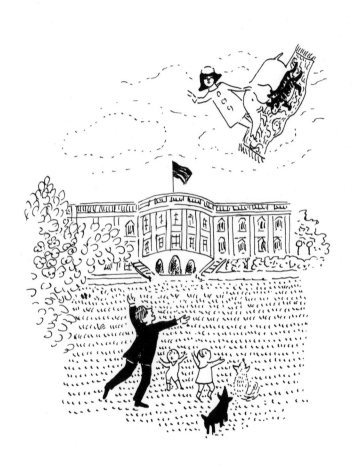

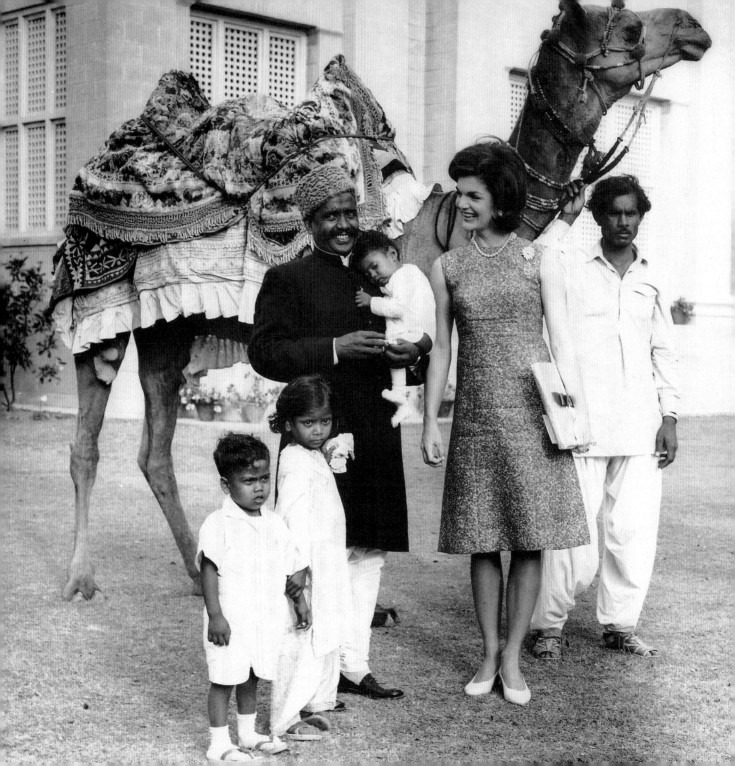

Mrs. Kennedy Goes Abroad

Jacqueline Duhême
Introduction by John Kenneth Galbraith
Text by Vibhuti Patel

ARTISAN
in association with Callaway
New York

FRONTISPIECE: Mrs. Kennedy with camel driver Bashir Ahmed and his children in Karachi, Pakistan, March 25, 1962.

BELOW RIGHT: A suitcase like this one was supplied for every member of Mrs. Kennedy's touring company in 1962.

BELOW LEFT: The Kennedys arrive at Orly Airport in Paris, May 31, 1961.

Designed by Jennifer Wagner

Library of Congress Cataloguing-in-Publication Data

DUHÊME, JACQUELINE.
MRS. KENNEDY GOES ABROAD / BY JACQUELINE DUHÊME
p. cm.
ISBN 1-57965-123-2

1. Kennedy, John F. (John Fitzgerald), 1917–1963—Journeys—France—Paris—Pictorial works.
2. Onassis, Jacqueline Kennedy, 1929–1994—Journeys—France—Paris—Pictorial works.
3. Visits of state—France—Paris—Pictorial works. 4. Duhême, Jacqueline.
I. Title.
E842.1.D85 1998
973.922'092—dc21 98-18686
CIP

Published in 1998 by Artisan,
a Division of Workman Publishing Company, Inc.
708 Broadway, New York, NY 10003
in association with Callaway Editions

Printed by Palace Press International in Hong Kong
10 9 8 7 6 5 4 3 2 1
First Printing

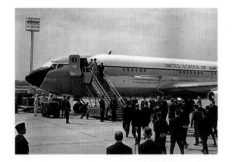

PHOTO CREDITS: pp. 4, 10, 18, 52, National Archives; pp. 14, 22, 24 (bottom), 28, UPI/Corbis-Bettmann; p. 16,
Archive Photos; pp. 20, 40, 44, 56, AP/Wide World Photos; p. 24 (top), Vital, Scoop/Paris Match; pp. 8, 58, John F. Kennedy Library.

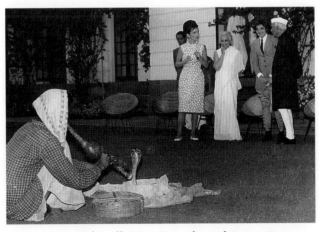

Princess Lee Radziwill, Mrs. Kennedy, and Prime Minister
Nehru entertained by a snake charmer in Nehru's garden,
March 14, 1962.

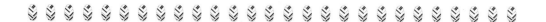

Introduction

The state visit, that of a head of state or someone in close association therewith to the high officials of another country, is our least understood public ceremony. Officially and in all public discourse, it is said to be for a compelling political purpose: mutual understanding, the resolution of troublesome differences of view, to win better knowledge of the government and people of another land. This, press, television, and radio all accept. There is extensive and solemn reporting on what will be, or has been, accomplished. It is a wonderful exercise in harmless fraud.

Much, perhaps most, official travel is, in fact, for the enjoyment of those making the visit and the leaders and public of the country being visited. For those who come there is escape, however brief, from the routine of official life and its political conflict and abuse. Instead the delights of well-arranged travel, effusive welcome, entertainment, and a new scene. None of this is ever noted by the accompanying or welcoming journalists and other commentators. They too are enjoying it and they are on expense accounts; they can't say the trip was largely fun. To repeat, a great though amiable

From left: Indira Gandhi, John Kenneth Galbraith, Mrs. Kennedy, and Prime Minister Nehru in New Delhi, March 1962.

fraud not lessened by the fact that the participants—the visitors and the visited—mostly do not realize it.

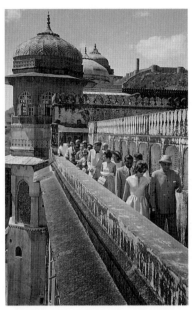

A few have, and one was Jacqueline Kennedy. As this charming book tells, she vastly enjoyed her visits to France and later to Rome, India, Pakistan, and London. Especially perhaps India. And she was not at all under the impression that she was changing the course of history; the thought would have amused her. She accepted fully that she was to enjoy herself and add to the enjoyment of the people she was visiting. This was sufficient; why more? Official life, as said, can be a stolid, commanding, depressive thing. How good for both the visitor and the visited that there can be these occasions of highly agreeable escape. Of such escape, in painting, photographs, and brief text but especially in painting, these pages tell.

Mrs. Kennedy, with Lee Radziwill and Ambassador Galbraith following behind, touring a temple in Jaipur, March 1962.

My wife Kitty and I planned Jacqueline Kennedy's trip to India. We resisted a proposal that she visit the ancient temple of Konarak, where her viewing of the explicitly erotic statuary would have greatly attracted the media instinct which later was so rejoiced by Bill Clinton. We were her hostess and host until Jawaharlal Nehru, one of the most distinguished statesmen of his age, snatched her away. The American embassy residence in New Delhi was then under construction; our dwelling was too small so we had requisitioned nearby accommodations. Nehru held them to be inadequate and moved Jackie and her

sister, Princess Lee Radziwill, to rooms in his own house. This was not a simple act of grace: Meeting her at the plane and seeing her later, he was enormously attracted and wanted to see more of her, which as the visit passed he did. As these pages tell, she went on to see the great sights of northern and western India. She enjoyed it all and in the years to come returned to India to become a highly sensitive student of Indian art.

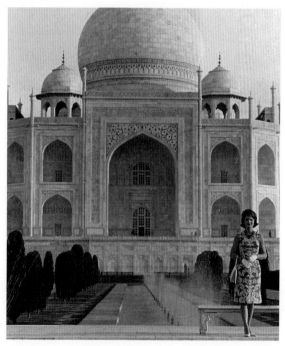

Mrs. Kennedy in front of the Taj Mahal, March 1962.

This brings me to the present book. Though I was thought to be much in charge of Jacqueline Kennedy's Indian trip, there was one important thing I did not know. It was that she had invited a very talented artist and friend to supplement and improve on the repetitive and sometimes tedious photographic record of the journey. Let there be an accomplished, diverting, and often richly amusing story in painting.

The artist, Jacqueline Duhême, Jackie had come to know from an earlier trip to Paris. She later saw and greatly appreciated (as did JFK) the paintings that Madame Duhême did of this visit—the paintings here shown. They

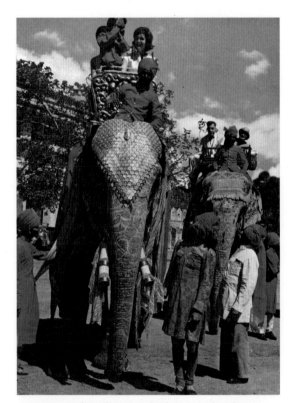

Mrs. Kennedy riding an elephant, with John Kenneth Galbraith following on another elephant, in Jaipur, March 1962.

invited her to Washington and Cape Cod and became good friends. From this friendship came the invitation for this truly talented artist to go with Jackie to Rome, India, and Pakistan. It is a wonder that her delicious, affectionate, and amusing work was not long ago made available to a much larger public. But better—in this case very much better— late than never.

To return to my earlier point: How well this book affirms the view that official trips can be for the enjoyment of visitor, visited, and, I venture, also for an accompanying artist. All, looking at the account and the pictures of the visit to France, will think of JFK's well-remembered comment that he was the man who accompanied Jacqueline Kennedy to Paris. All going on to the visit to India and Pakistan will be in no doubt as to its unsullied pleasure. This book celebrates both Jacqueline Kennedy and Jacqueline Duhême and the good time that was had by all. And now those who see and read about it.

—JOHN KENNETH GALBRAITH

"Vive Jacqueline!"

Paris, May 31, 1961

On their first trip abroad since the inauguration, President and Mrs. Kennedy went to Paris in 1961 at the invitation of the French president. In the *salon d'honneur* of Orly Airport, General de Gaulle welcomed JFK and "la gracieuse Mme Kennedy." President Kennedy's mother traveled from her villa in the south of France to join the couple in Paris. The thirty-one-year-old First Lady was in a state of bliss to be back in her beloved Paris, the city that she had often visited as a child and in which she had lived for a year as a college student.

Then the two presidential couples rode through the Place de la Concorde led by the cavalry of the plumed Republican Guard as the city was shaken by a 101-gun salute. A holiday had been declared in honor of the American visit and the streets were jammed with five hundred thousand people chanting, "Vive le President! Vive Jacqueline!"

"La belle Jacqui," herself of Gallic descent, attracted much of the crowd; her nationally broadcast television interview, during which she spoke "in fluent French with a charming accent," according to *Le Figaro*, had enchanted Parisians the day before.

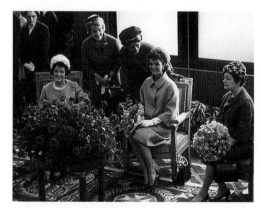

Seated, from left: Mrs. Joseph P. Kennedy, Mrs. Kennedy, and Mme de Gaulle.

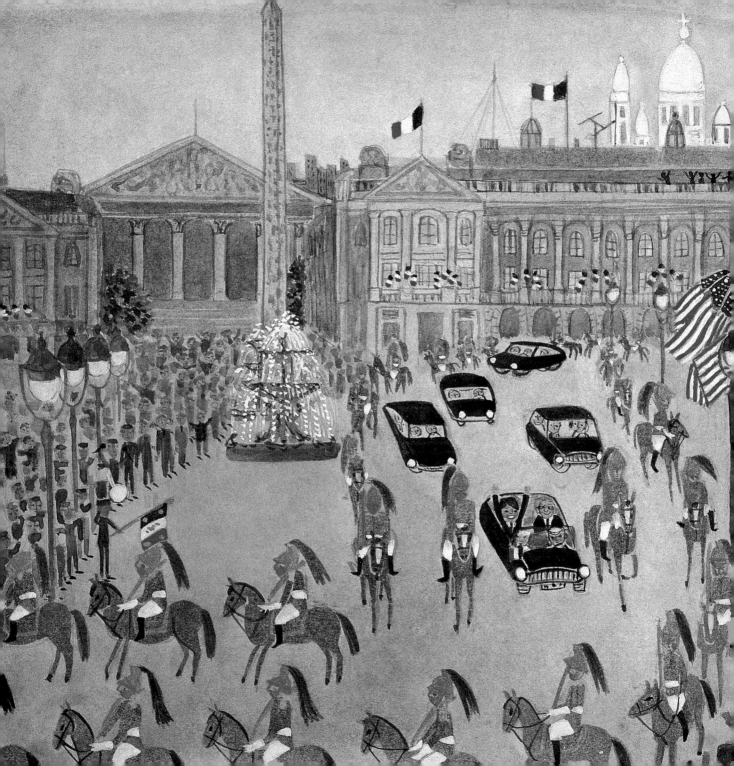

Fit for a Queen

PARIS, May 31, 1961

The Kennedys settled into a five-salon suite in the French Foreign Ministry's
mansion on the Quai d'Orsay, which was built in 1845 by Louis Philippe.
Their rooms, overlooking the courtyard's magnificently restored gardens, were
decorated with celebrated French paintings loaned by the Louvre in recognition
of Mrs. Kennedy's passion for art. In the *Chambre de la Reine*, Jacqueline slept
in a bedroom last occupied by Belgium's Queen Fabiola, bathed in a silver
mosaic tub set in the mother-of-pearl bathroom originally designed for Britain's
Queen Elizabeth II, and gazed up at a ceiling covered with Napoleonic cherubs.
A new hairstyle was created for her every morning by the famous French stylist
Alexandre, to whom she had secretly sent a lock of her hair from Washington
in preparation.

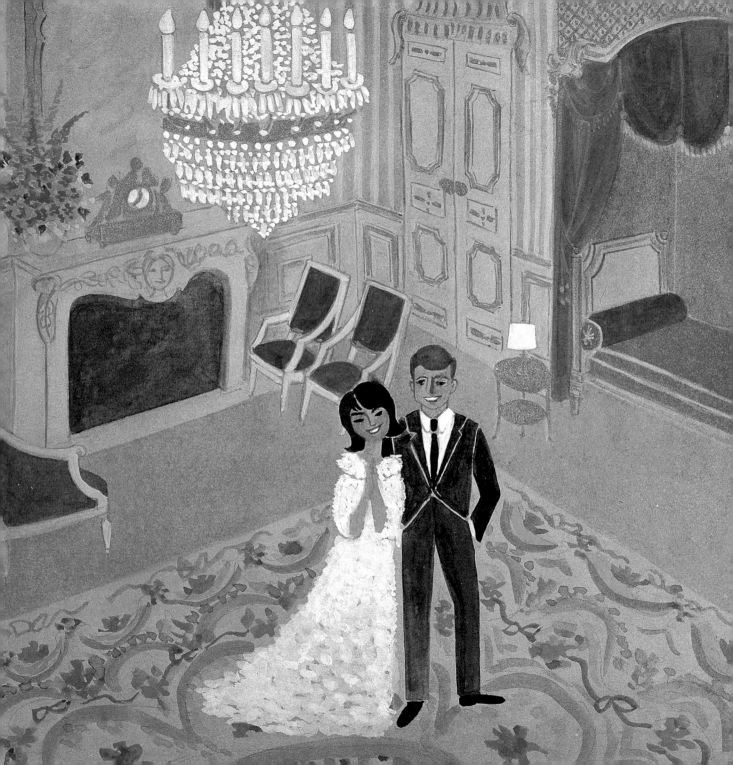

Chez les de Gaulle

PARIS, May 31, 1961

For their American visitors, the de Gaulles hosted an intimate five-course luncheon at the presidential Elysée Palace. The elegant menu included *langouste à la Parisienne* and *foie gras en gelée*. Mrs. Kennedy wore a yellow silk suit with a matching pillbox straw hat—the hat that would become as much a part of her style signature as the French cuisine that she introduced into the White House. After lunch, de Gaulle gave JFK an autographed portrait of himself in a silver frame and Mrs. Kennedy a small vanity case made of spun gold, encrusted with diamonds. President Kennedy gave the general a Louis XVI cabinet. The year before, on his visit to Washington, de Gaulle had said wistfully, "If there were anything I could take back to France with me, it would be Mrs. Kennedy."

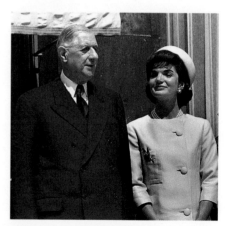

President de Gaulle and Mrs. Kennedy outside the Elysée Palace.

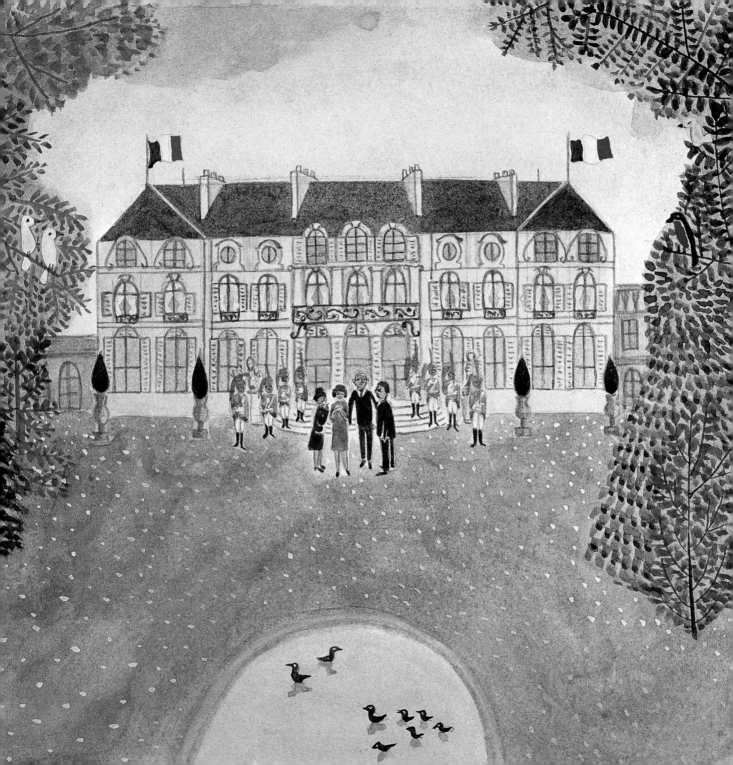

A Shared Love for Children

PARIS, May 31, 1961

An easy rapport had developed between Mrs. Kennedy and Yvonne de Gaulle, so she was happy to make a visit to an infant-care nursing school that was a special interest of Mme de Gaulle. Outside she was greeted by an applauding crowd; inside, she was welcomed by teams of student nurses. Mrs. Kennedy admitted that she was very disappointed not to have attended the school herself when she was a student in Paris. She loved children, and she always carried treats for them when she traveled. Her gift to the children's center was brightly colored modern furniture that she had sent to liven up the drab waiting room.

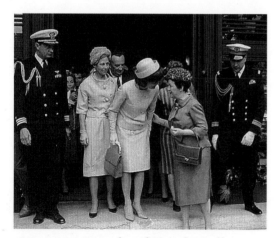

Center, Mrs. Kennedy and Mme de Gaulle.

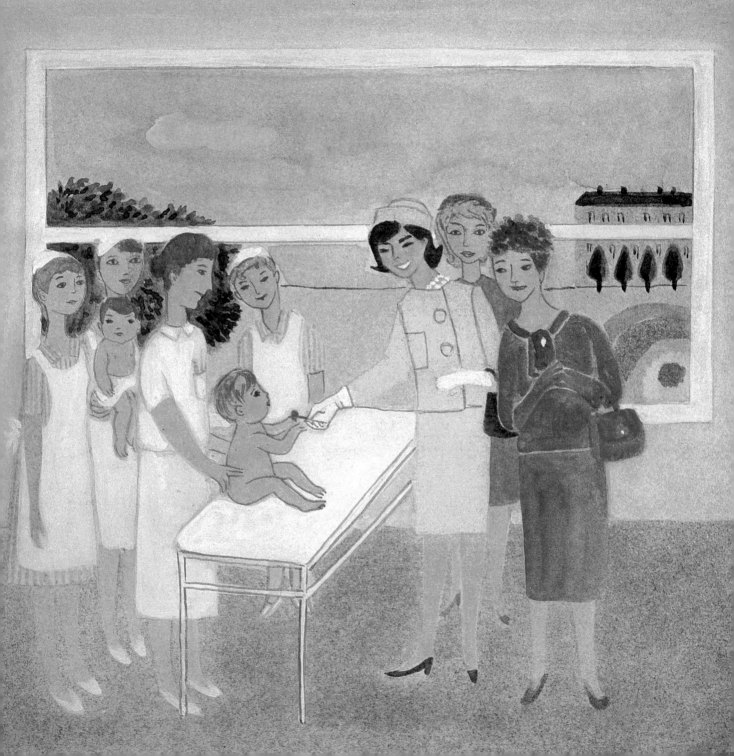

At the Arc de Triomphe

PARIS, May 31, 1961

President Kennedy laid a wreath beneath the Arc de Triomphe, the majestic memorial to Napoleon's victories, then rekindled the eternal flame at the Tomb of the Unknown Soldier. The image of these two leaders standing side-by-side at this symbolic ceremony—President Kennedy in a business suit, General de Gaulle in his military uniform—underscored the contrast between the two leaders and the two countries they represented. JFK later toasted de Gaulle as "the only great leader of World War II who occupies a position of high responsibility" and referred to himself as "a junior figure on this field, which he has occupied for more than twenty years."

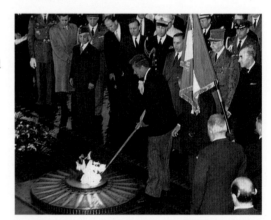

President Kennedy lighting the flame as President de Gaulle looks on, from right.

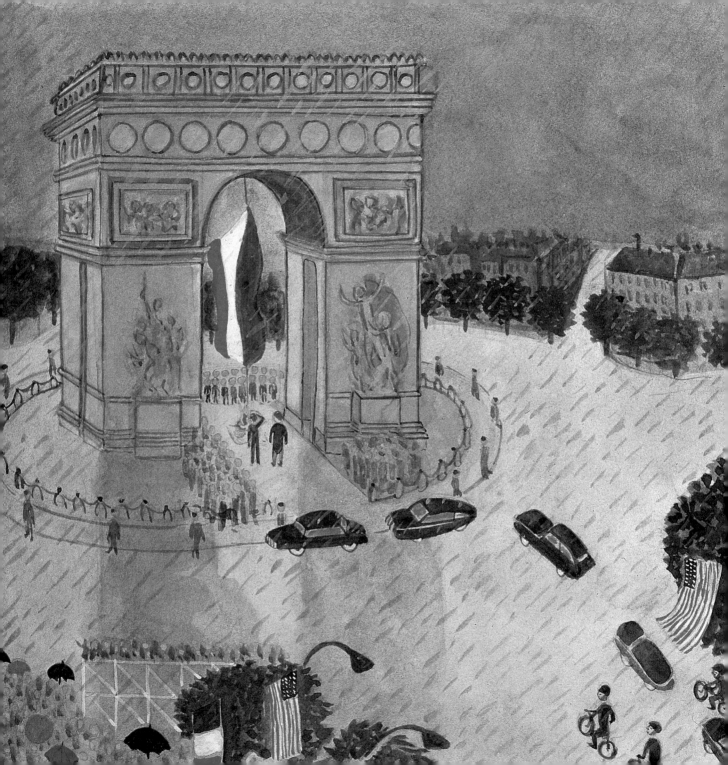

Elegance at the Elysée

Paris, May 31, 1961

At a formal dinner banquet at the Elysée Palace that evening, Mrs. Kennedy wore a narrow, pink-and-white straw-lace gown, created by her official American designer, Paris-born Oleg Cassini. Hair stylist Alexandre spent two hours fashioning a "Gothic Madonna" coiffure, crowned with a false topknot and a diamond rose. "I am dazzled," said an awed President Kennedy. Even the high priestesses of French fashion echoed, *"Charmante!" "Ravissante!"* As the orchestra played Ravel and Gershwin beneath glittering chandeliers, three hundred guests enjoyed a delicious meal served on Sèvres china alongside Napoleon's vermeil. After dinner, the de Gaulles, whom *Time* magazine said looked like the "parents of the bride" in a receiving line next to the Kennedys, greeted one thousand Parisian luminaries. By midnight, Jacqueline's white glove was stained from shaking so many hands.

The Kennedys returning to the Quai d'Orsay after dinner.

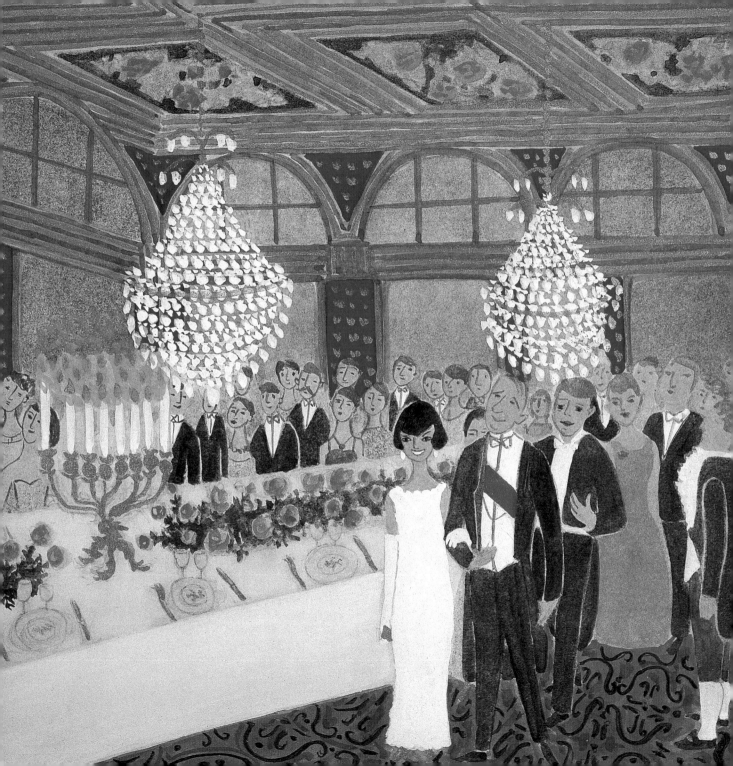

Hosted at the Hôtel de Ville

PARIS, June 1, 1961

The next day the Kennedys were received by the chief mayor of Paris at the city seat of government, the Hôtel de Ville. Mrs. Kennedy, in an austere navy blue silk suit, attracted more attention than the President, who joked, "I do not think it altogether inappropriate to introduce myself. . . . I am the man who accompanied Jacqueline Kennedy to Paris, and I have enjoyed it." Jacqueline accepted the City of Paris's gift—a tiny watch with an exquisite diamond hood—with obvious pleasure. "I'm enjoying this trip terribly," she murmured in French and then delighted Parisians with her admission that she longed to "walk around and look at the buildings and the streets and sit in the cafés."

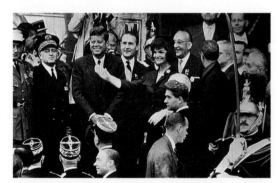

The Kennedys outside the Hôtel de Ville.

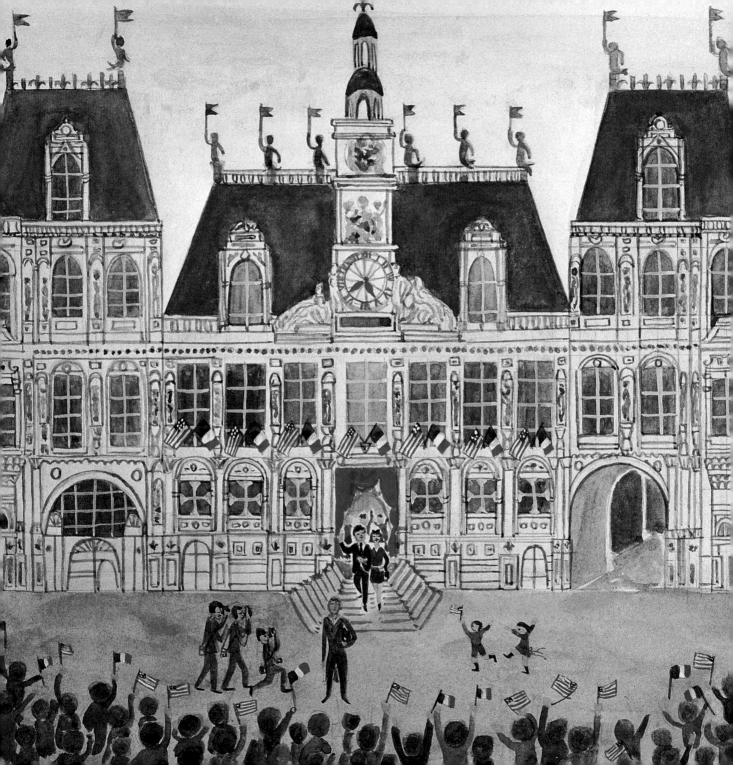

Apotheosis at Versailles

PARIS, *June 1, 1961*

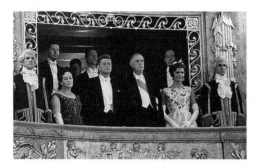

From left, Mme de Gaulle, President Kennedy, President de Gaulle, and Mrs. Kennedy.

At a soirée in Louis XIV's Versailles palace, the Kennedys savored a night of true French grandeur. After dining in the majestic Hall of Mirrors, they attended a ballet in the sumptuous Louis XV jewel-box theater. In the course of the evening, Jacqueline dismissed the interpreter and herself translated for the two presidents. In her low, melodic French she drew de Gaulle into long, entertaining conversations with JFK.

The general was enchanted and would later recall, "She played the game very intelligently. Without mixing in politics, she gave her husband the prestige of a Maecenas." Mrs. Kennedy's gown, made by her favorite French designer, Hubert de Givenchy, honored the tricolor flag with its red-and-blue appliquéed bodice over a slim white satin skirt. During the show, Jacqueline and President de Gaulle drew their chairs back into the box and chatted quietly. After the ballet, the Kennedys strolled arm-in-arm alone through the mist-covered gardens. The next day, *France-Soir* trumpeted Jacqueline's presence as an "Apotheosis at Versailles!"

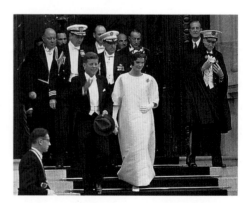

The Kennedys leaving their Quai d'Orsay suite for Versailles.

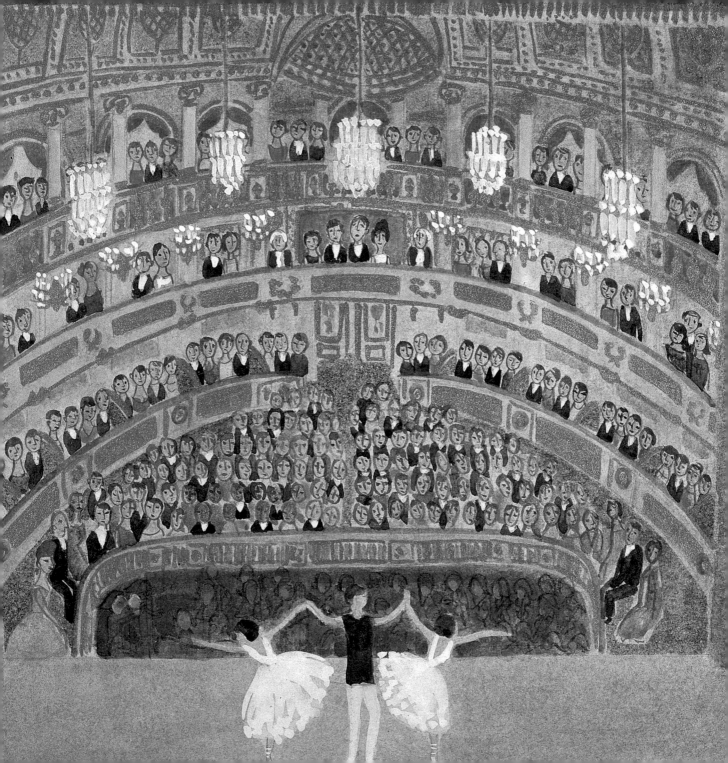

A Passion for Paintings

PARIS, June 2, 1961

In a hastily arranged "stolen pleasure," Mrs. Kennedy stopped by the small Jeu de Paume museum, known for its fine collection of Impressionist paintings. Her escort was André Malraux, France's Minister of Culture. "I have just seen the most beautiful paintings in the world," Jacqueline said of the works by Dégas, Manet, Monet, Renoir, and Seurat; she declared Manet's dramatic nude "Olympia" her favorite. A visit to Malmaison, Josephine Bonaparte's country retreat, followed, and a gourmet lunch at La Celle St. Cloud, the former hideaway of Madame de Pompadour, Louis XIV's famous mistress, concluded Jacqueline's museum morning.

ADMIRING MANET'S "OLYMPIA" AT THE JEU DE PAUME

Goodbye to Paris

PARIS, June 2–3, 1961

Wearing a white cloche-style Givenchy hat, Mrs. Kennedy bid adieu to the de Gaulles at the Elysée before departing the next morning in a plane for Vienna. Parisians had fallen in love with Jacqueline, whose tact, charm, and sweet manners eased her husband's difficult mission. Now, it was evident how much of a political asset she was to her husband and her country. "French-American relations have just made a new start. . . . President Kennedy's knowledge of the problems, the intelligence of his remarks, his gift of getting directly to essentials, struck all those who came to hear him," wrote *Le Monde*. Impressed with the American president's clarity of thinking, culture, and courage, General de Gaulle admitted, "He's much superior to everything that has been said or written about him."

Mrs. Kennedy would prove to be a diplomatic advantage again in Vienna, where, during President Kennedy's meetings with Soviet Premier Nikita Khrushchev, her disarming presence helped allay the tension between the two Cold War leaders. Her experience interacting with de Gaulle and Khrushchev was preparation for her own solo diplomatic tour, taken a year later when she traveled to India and Pakistan via Rome.

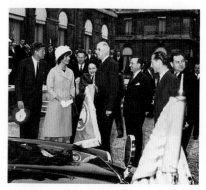

The Kennedys say goodbye to the de Gaulles at the Elysée.

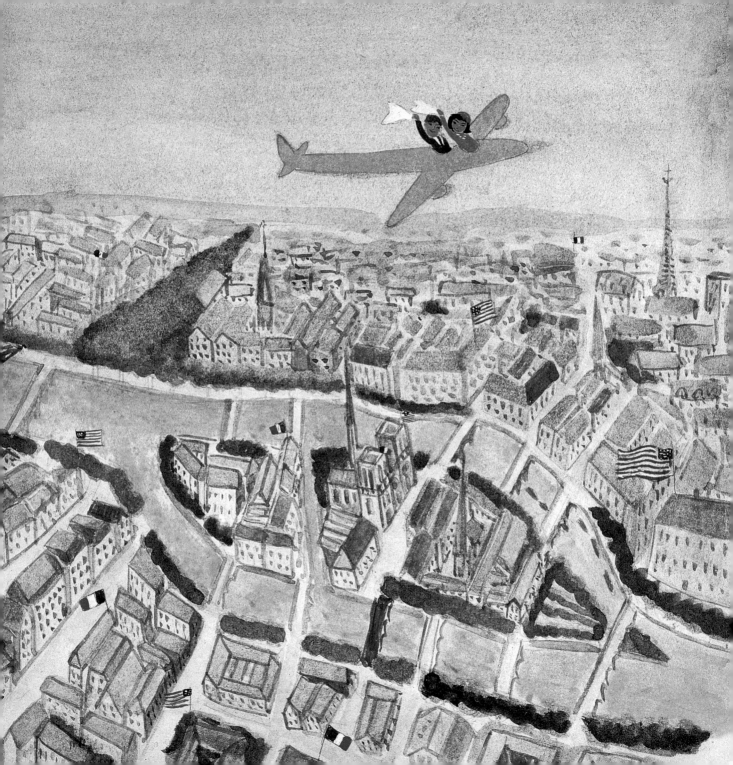

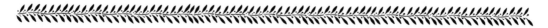

Roman Holiday

ROME, March 10, 1962

En route to India and Pakistan, on a 1962 goodwill tour with her sister,
Princess Lee Radziwill, the wife of America's first Catholic president stopped
in Rome for an audience with Pope John XXIII. *"Che bella!"* cheered a
thousand Romans, gathered at the airport to welcome a beaming First Lady,
clad in a stylish Somali leopard-skin coat and a black mink pillbox.
Mrs. Kennedy also visited with the president of Italy, dined with a Harvard
friend of her husband's in his Renaissance palazzo, and stayed overnight
at the American embassy.

Private Audience with the Pope

ROME, March 11, 1962

For her Sunday morning private audience with the eighty-year-old Pontiff, the thirty-two-year-old First Lady dressed in a black full-length dress of heavy silk, with long gloves and a black Spanish lace mantilla that covered all but her face. Pope John XXIII, who seemed diminutive next to Mrs. Kennedy, conversed with her in his resplendent Vatican library for 32 minutes—quite a long time considering that it was highly unusual when Britain's Queen Elizabeth II had spent 26 minutes with him the previous spring. Mrs. Kennedy and the Pope spoke in French, since he was not fluent in English. She gave him a personally inscribed copy of JFK's speeches; he gave her rosaries and medals of his Pontificate. Catholic by birth, Jackie was visibly moved by the meeting. Later, a mass was offered for her, and the Pope received other members of her party—with the exception of her sister, who was divorced.

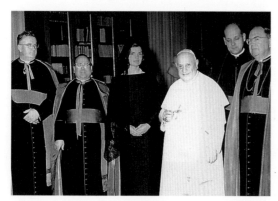

At center, Mrs. Kennedy with Pope John XXIII.

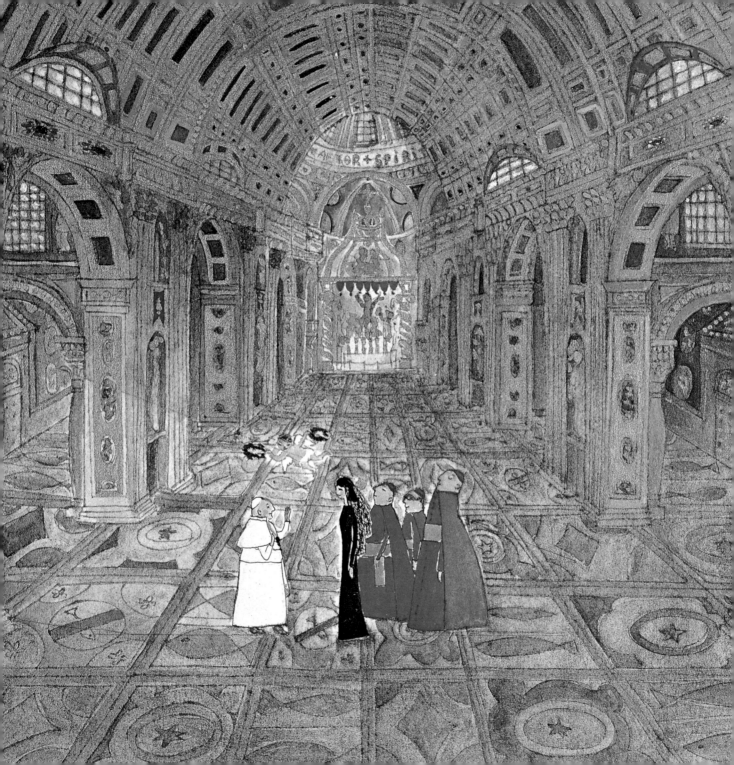

Arrival in India

NEW DELHI, March 12, 1962

Mrs. Kennedy was met at the New Delhi airport by Prime Minister Jawaharlal Nehru, his daughter Indira Gandhi, and John Kenneth Galbraith, her host on this "semi-official" visit. Nehru had left the opening session of Parliament early and was waiving protocol to greet this visitor who was not a head of state. On the long road into the city, one hundred thousand people, including villagers in bullock carts parked wheel to wheel, lined the wide streets of the British-built capital to hail the "Amriki Rani!" (Queen of America). Jacqueline and Lee stopped to watch the formal procession of President Rajendra Prasad as he left Parliament in a regal black-and-gold landau drawn by six sorrel horses and surrounded by seventeen outriders in scarlet coats and enormous turbans.

Mrs. Kennedy watches the presidential procession from Parliament.

THE PRESIDENTIAL PALACE, RASHTRAPATI BHAVAN

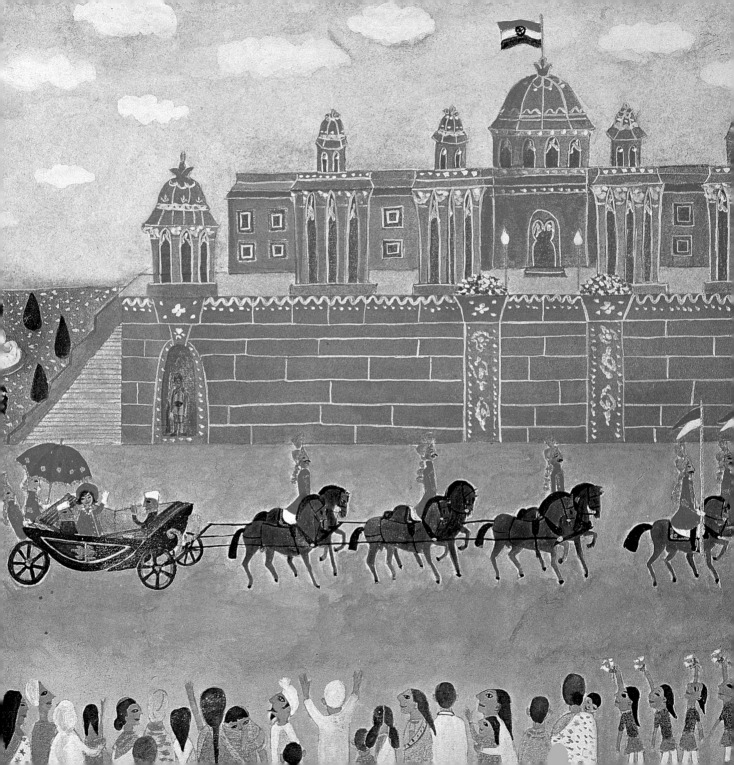

Charmed in Nehru's Garden

New Delhi, March 13–14, 1962

At lunch, Mrs. Kennedy sitting opposite President Prasad and between Prime Minister Nehru and Vice President S. Radhakrishnan.

At Rashtrapati Bhavan, the opulent palace built for British Viceroys in 1911, President Rajendra Prasad hosted a luncheon for one hundred in honor of the First Lady. It was followed by a small formal dinner, at which Mrs. Kennedy wore a satin Cassini gown. The next morning, Jacqueline received a surprise invitation to ride with ten scarlet-uniformed officers of the President's Guard. As she flew over a jumping course in the city's polo grounds, her flawless riding impressed the officers. But Jacqueline credited her mare Shahzadi (Princess): "She jumped like a bird." In Nehru's garden after her ride, a cobra swayed to a snake charmer's pipe. But when the show turned into a bloody fight between the cobra and his natural enemy, a mongoose, Jacqueline recoiled, shrinking against Nehru in horror.

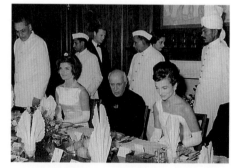

From left, Mrs. Kennedy, Prime Minister Nehru, and Princess Lee Radziwill at Nehru's dinner.

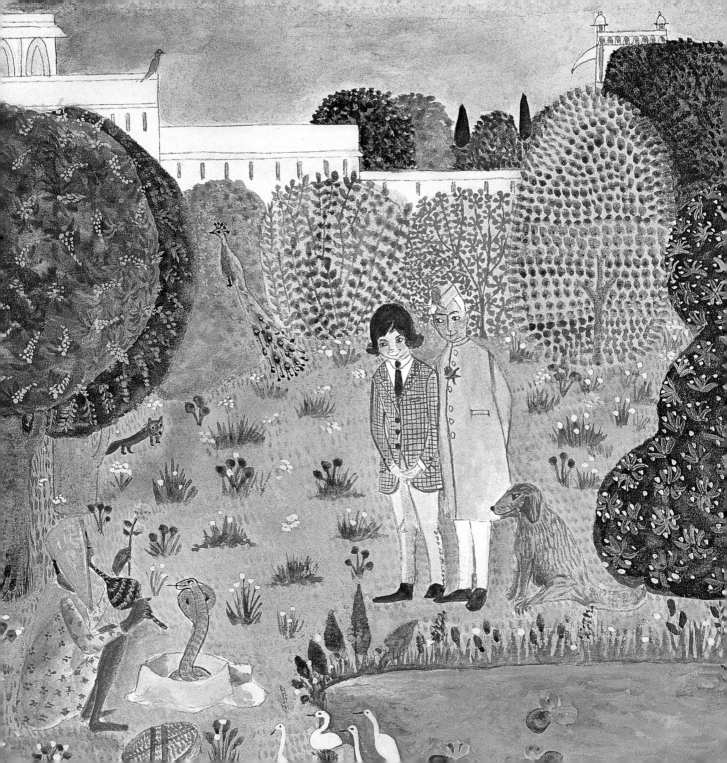

Some Unexpected Admirers

NEW DELHI, March 14, 1962

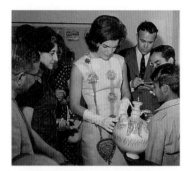

Indira Gandhi watches as Mrs. Kennedy is presented with an earthen pitcher.

Indira Gandhi, acting as official hostess, guided Mrs. Kennedy on a tour of Bal Sahyog, a halfway house for boys. Jacqueline joked easily with them, and was surprised—and pleased—to see pictures of herself on their walls. She peeked in a dormitory, inspected the library and vocational classes, and admired the furniture the students had made in the workshop. One boy gave her a flower stand he had crafted especially for Caroline.

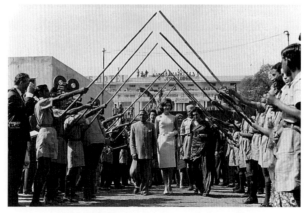

Mrs. Kennedy and Indira Gandhi saluted at Bal Sahyog.

BOYS WELCOMING MRS. KENNEDY TO BAL SAHYOG

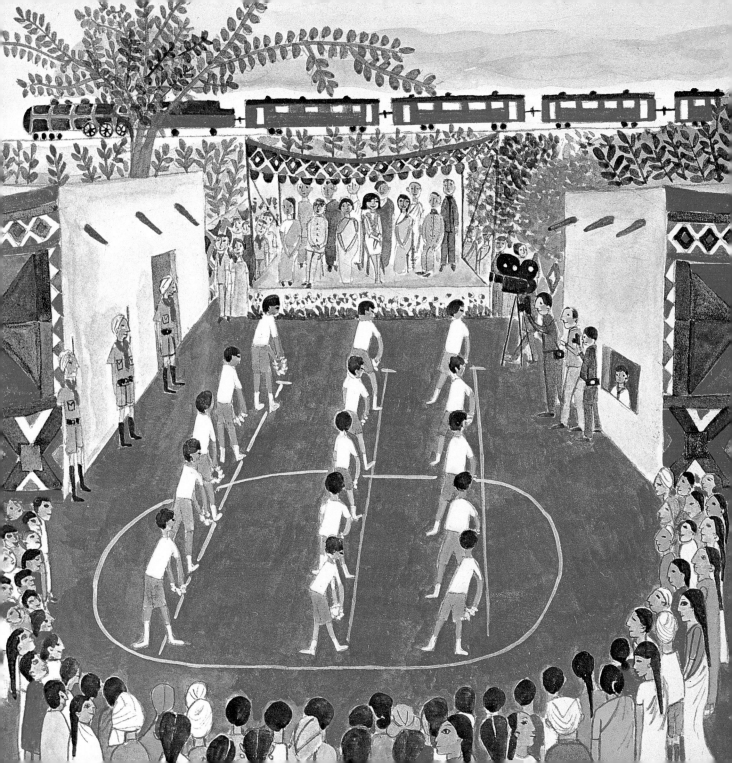

A Gargantuan Gift

NEW DELHI, March 14, 1962

Air India presented Mrs. Kennedy, a devoted animal lover, with twin Bengal tiger cubs. Jacqueline announced jokingly that she would name them Ken and Kitty, after the Galbraiths, and planned to keep them at the White House with Caroline's dogs, Charlie and Pushinka, until they reached the "scratchy" age (when they would be given to a zoo). Prime Minister Nehru gave her a baby elephant named Urvashi. Jacqueline fed the eleven-month-old sugar cane, bananas, and milk from a bottle which Urvashi spilled on the First Lady's skirt. Ms. Gandhi scolded Urvashi for her poor table manners, but Mrs. Kennedy sprang to the animal's defense, "Oh no. She's being very good."

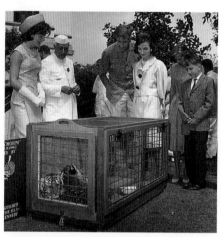

Mrs. Kennedy, Prime Minister Nehru, Ambassador Galbraith, and Princess Radziwill looking down on the two tiger cubs Mrs. Kennedy received as gifts.

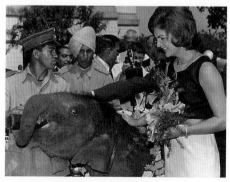

Mrs. Kennedy pets her baby elephant.

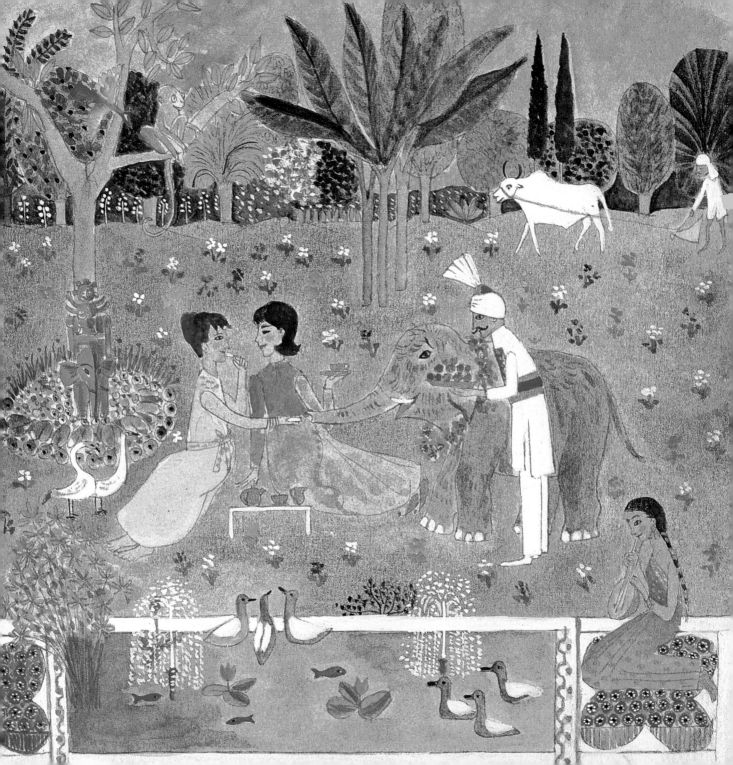

The Presidential Train

NEW DELHI, March 15, 1962

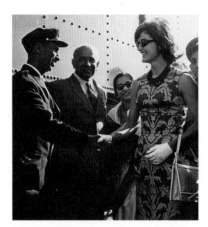

Mrs. Kennedy meets the conductor.

After three days in the capital, Jacqueline and Lee took President Prasad's train to venture into northern India. Their first stop was Agra, home of the Taj Mahal. The train had been outfitted for the First Lady with pastel bedrooms, handloomed curtains, embroidered cashmere bedspreads, sandalwood soaps, even specially installed dressing tables. Jacqueline enjoyed riding in this train so much that she would later choose it over a plane, despite the extra day of travel.

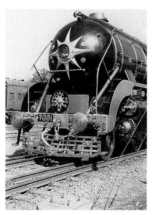

The presidential train, gathering steam.

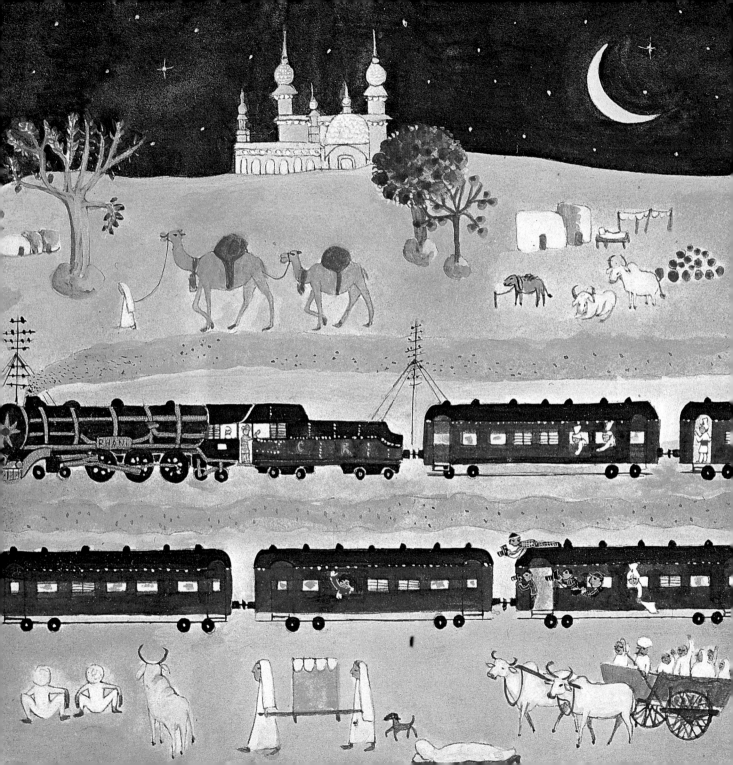

A Dream at the Taj Mahal

AGRA, March 15, 1962

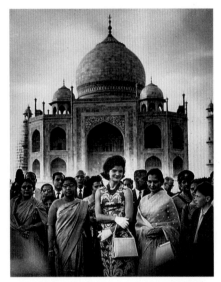

Mrs. Kennedy in front of the Taj Mahal.

The Taj Mahal was built in the seventeenth century over a period of twenty-two years, under the direction of the grandson of Mogul Emperor Akbar, Shah Jahan, who wished to commemorate his beloved queen, Mumtaz Mahal. As the setting sun cast shadows from the cypresses lining its reflecting pools, the First Lady seemed spellbound by the shimmering white marble mausoleum. "I am overwhelmed by a sense of awe," she said. "I have seen pictures of the Taj, but for the first time I am struck with a sense of its mass and symmetry." She returned later that day to see the Taj by moonlight.

"She looked so young, simple, unaffected against the extraordinary beauty of the domed Taj and its four graceful minarets that Shah Jahan himself would have approved!" wrote one reporter.

Down the Ganges River

Benares, March 16, 1962

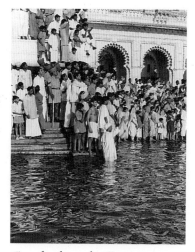

Crowds along the Ganges.

The presidential train brought the First Lady from Agra to Benares, where twenty tailors had worked all night to make silk drapes and bedspreads for her suite in the holy city, which is one of the oldest still-inhabited cities in the world. On that hot morning, Jacqueline appeared hatless and stockingless in a shocking-pink dress that complemented the jewel tones of India. She boarded a boat garlanded with marigolds to view the bathing spots and cremation platforms along the riverside. Scarlet-liveried bearers sheltered Jacqueline and Lee with parasols as large crowds along the banks blew deafening blasts on conch shells and banged on triangles in excitement and appreciation. Later, Jacqueline walked up a petal-strewn path to Sarnath Stupa, the temple from which the Buddha preached his first sermon two thousand five hundred years ago.

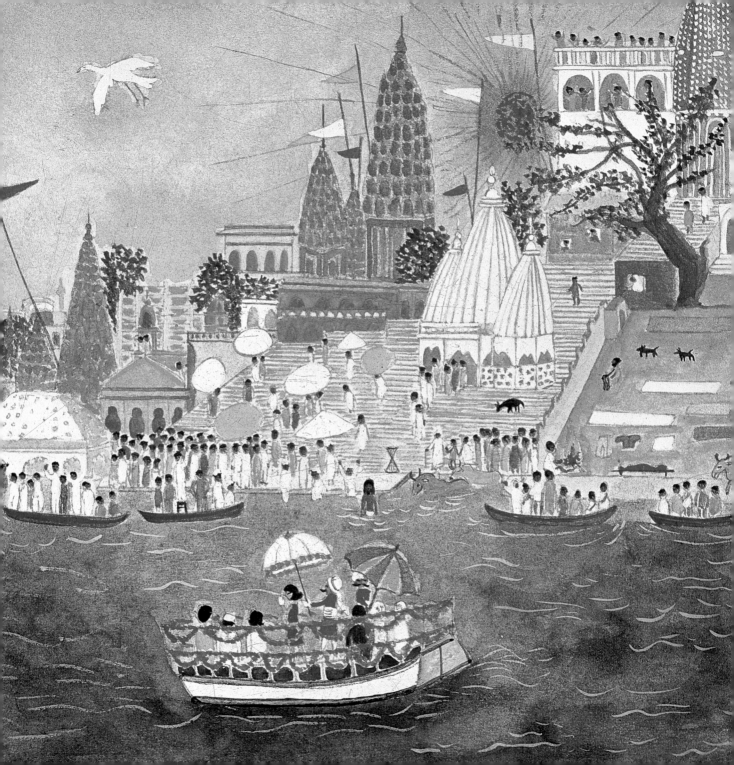

Boating to the White Palace

UDAIPUR, *March 17, 1962*

In Udaipur, the capital of the northwestern Indian state of Rajhastan, "the land of kings," the crowds that welcomed Mrs. Kennedy were greater than they had been for any other visitor in recent memory, including Queen Elizabeth. On a boat ride to the exquisite White Palace on an island in picturesque Lake Pichola, the First Lady wore a sashed apricot silk dress and covered her hair with a white chiffon scarf; Princess Radziwill wore a white crocheted coat over a cerise dress. "They looked as beautifully out of this

Mrs. Kennedy waves from her boat on Lake Pichola.

world as Udaipur and its palaces," the *Washington Post* reported. That evening they were guests of the Maharana of Udaipur at a huge storybook palace inlaid with mosaic and mirrorwork. A grand party in Jacqueline's honor featured traditional dancers who performed under crystal chandeliers with light globes shaped like lotus blossoms showering towards the ground.

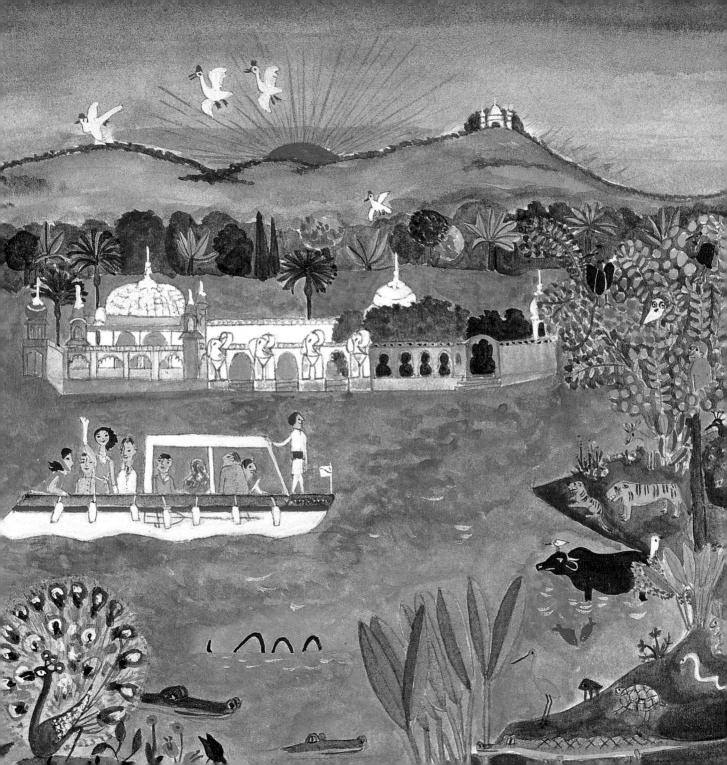

A Stroll through Shalimar Gardens

LAHORE, *March 22, 1962*

After Mrs. Kennedy's nine-day visit to India—a visit that "added greatly" to what Nehru called the "psychological pull" of friendship between his country and the United States—the First Lady arrived in Pakistan to showers of flower petals, drums, and bursting balloons. President Ayub Khan gave her what would be her favorite gift from her trip—a ten-year-old bay gelding named Sardar (Chief). After a "get-acquainted canter," she declared, "No one [at home] will be allowed to ride him but me." That evening, President Khan accompanied her on a stroll through the fabled Shalimar Gardens, where seven thousand guests, most of them women, had gathered to see her. "All my life I have dreamed of coming to Shalimar Gardens," Jacqueline told reporters. "It is even lovelier than I had imagined. I only wish my husband could be here."

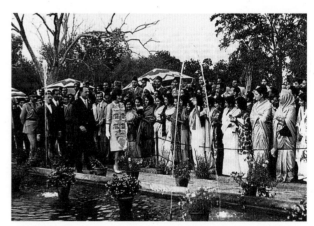

Mrs. Kennedy, wearing the traditional welcoming tinsel garland, in Shalimar.

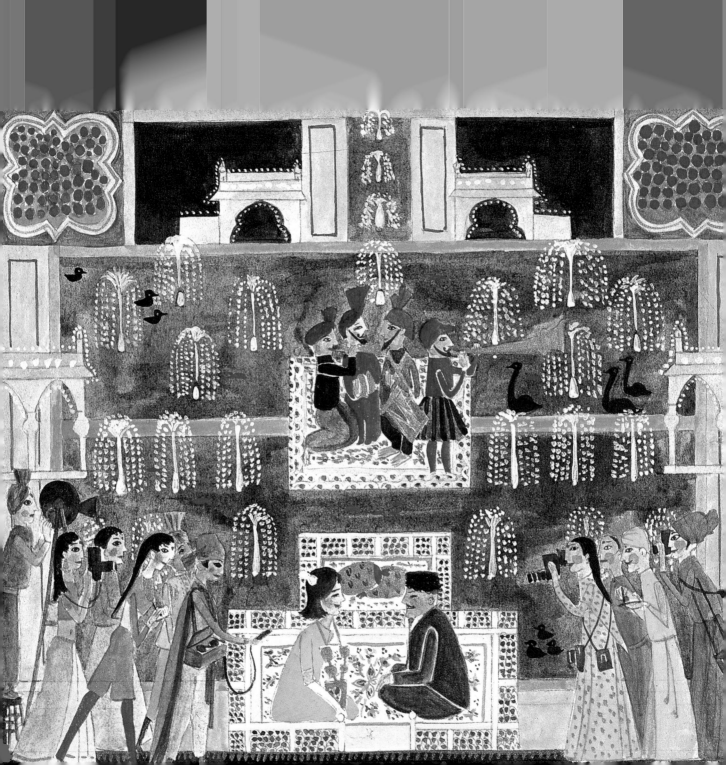

A Precarious Camel Ride

KARACHI, March 25, 1962

In Karachi, Mrs. Kennedy brought a personal message from Lyndon Johnson to camel driver Bashir Ahmed, who had previously come to the White House at the Vice President's invitation. Brushing off Bashir's protests and Pakistani officials' concern, Jacqueline insisted on a camel ride. When Lee began to decline the ride, Jacqueline spoke for her sister, telling everyone, "She would love to." Security men winced as the groaning camel jerked up from the ground and, unfolding its legs, pitched forward, up, and back. Remaining seated, side-saddle, on an uncomfortable camel is difficult. As for sitting astride, Jacqueline said, "We can't in these skirts." Riding around the backyard of the presidential residence, ducking under treetops, Lee lost her shoe while Jacqueline held the reins, backseat-driving from a perch behind Lee. The First Lady thoroughly enjoyed herself, though admitting, "It makes an elephant feel like a jet plane."

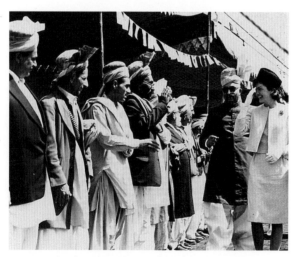

In Peshawar, the day before, Jacqueline salutes Pathan tribal Maliks (chiefs).

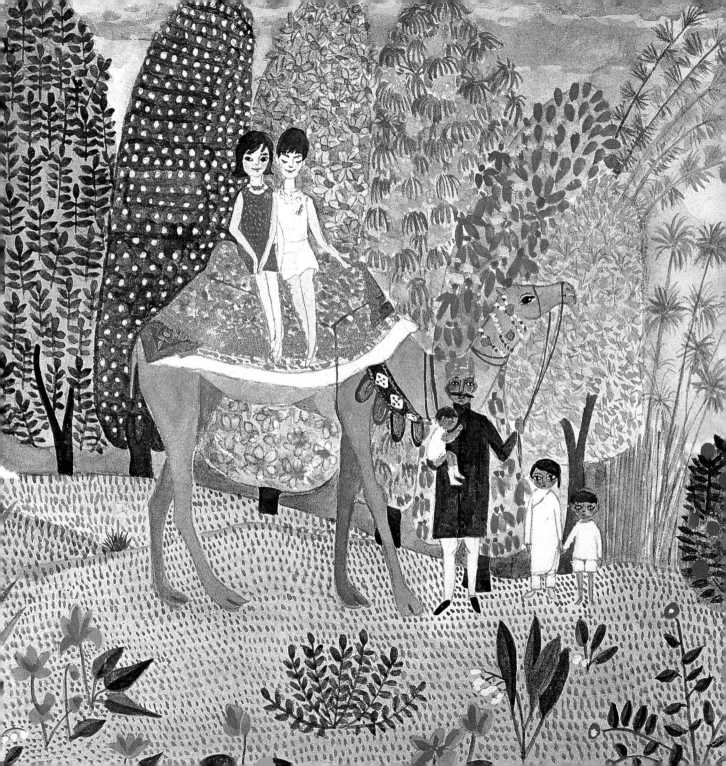

Resting Up

LONDON, March 26, 1962

Mrs. Kennedy, Anthony Radziwill,
and Princess Lee Radziwill.

After a thirteen-hour flight from Karachi via Tehran (where the First Lady and Princess Radziwill met Princess Fatima, the Shah's sister), they landed in London. Mrs. Kennedy danced down from the airplane to smile at the crowd and greet her nephew, two-and-a-half-year-old Anthony Radziwill. In reponse to reporters' questions, she replied, "I am very tired. I won't be going out at all in London except to have lunch with the Queen." With a two-day rest stop at her sister's townhouse, Jacqueline hoped to recover from the strenuous fifteen-day India-Pakistan tour. The Radziwills invited a few friends for an impromptu dinner and together they all watched the BBC's broadcast of the First Lady's White House tour.

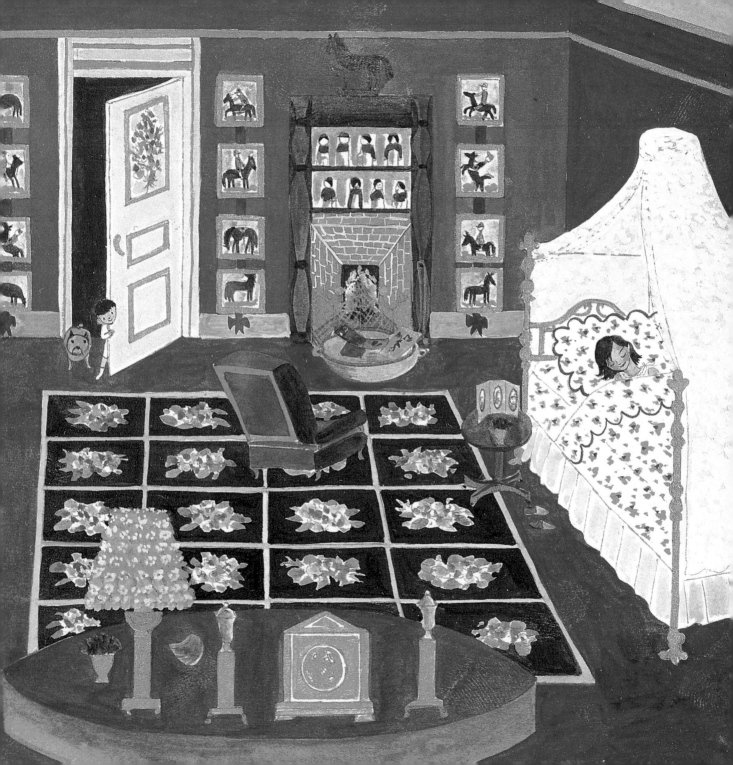

Lunch with the Queen

LONDON, March 28, 1962

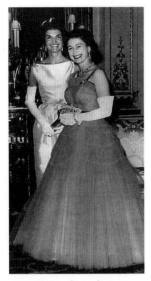

Mrs. Kennedy and Queen Elizabeth II at Buckingham Palace in June of 1961.

"I'm feeling full of beans and very excited about having lunch with the Queen," said Mrs. Kennedy as she set out for Buckingham Palace. "It's a great honor, and it is very kind of the Queen to invite me."

A court spokesman said Jacqueline was not invited simply for reasons of protocol but because the Queen and Mrs. Kennedy "have so much in common now"—both were in their thirties, mothers of young children, and constantly in the limelight. Jacqueline was served what she described as "a wonderful English lunch" in the same room where she and the president had dined at a state banquet the year before.

Leaving the palace, she said the conversation had been "mostly about India," and that she thought "the Queen's clothes were lovely and she was most gracious."

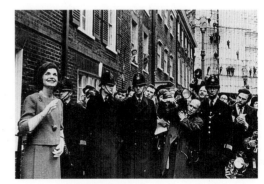

Mrs. Kennedy leaving her sister's townhouse for lunch with the Queen.

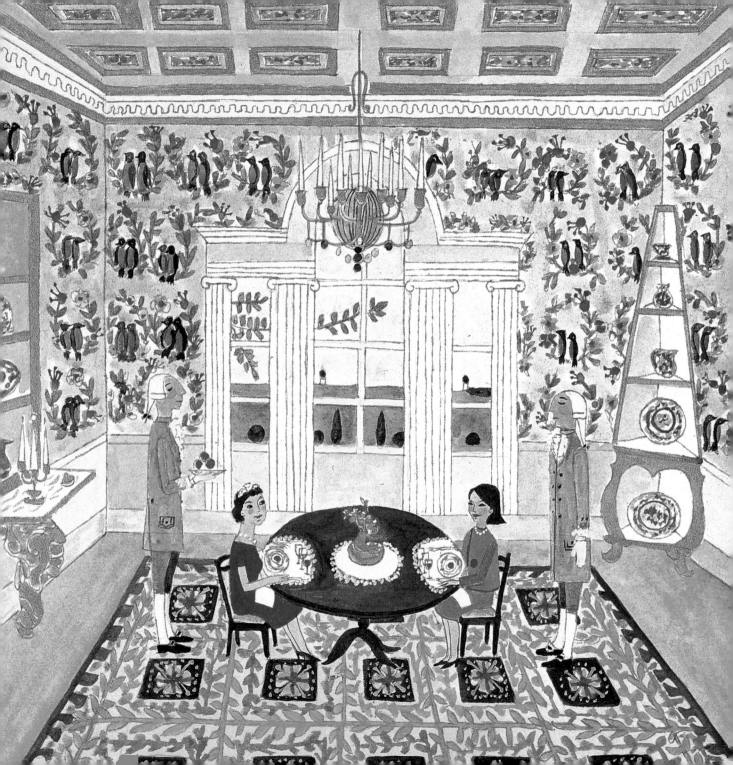

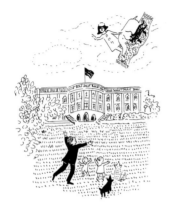

Home to the White House

WASHINGTON, D.C., March 29, 1962

Visiting Washington just before the First Lady's return, Indira Gandhi said that Mrs. Kennedy was "very charming, everybody loved her. . . . Her appeal is very different from that of an official diplomat." The *Times of India* reported, "Nothing else happened in India while Mrs. Kennedy was there. She completely dominated the scene." When she landed in Washington, the President rushed into her plane for a private welcome before whisking her home to the White House to see her four-year-old daughter Caroline and 16-month-old son John-John. At each stop on her trip, their mother had mailed separate picture postcards with Xs that they recognized as kisses from her. While admitting, "I have missed my family and I have no desire to be a public personality of my own," she summed up her trip as "the most magic two weeks of my life. . . . I never had such a marvelous time."

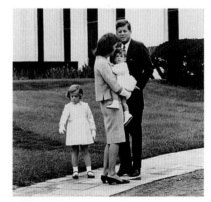

The First Family, on the West Lawn of the White House, a month after Jacqueline's return.

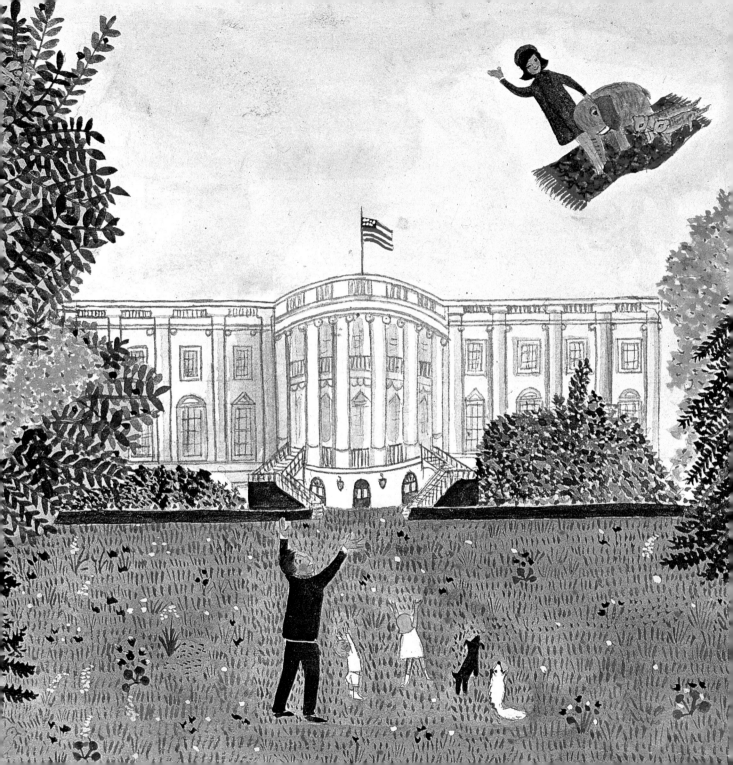

About Jacqueline Duhême

Jacqueline Duhême began her career as an artist at age eighteen when she went to Paris to study drawing with Paul Colin, the premier graphic designer of the time. At twenty-four, Duhême became the assistant of Henri Matisse in Vence in the south of France. There she met the poet Jacques Prévert, a friend of Matisse's. Duhême would become Prévert's favorite illustrator (especially for his children's books) and they had a long-lasting friendship. After her apprenticeship with Matisse, she returned to Paris to work on her own.

Duhême then began to illustrate stories for *Elle* magazine. Her goal was to become an "illustrator-reporter," and in 1961 the perfect opportunity arose with the Kennedys' state visit. Duhême met with Hélène Lazareff, the founder and head of *Elle*, and proposed to illustrate the trip for the magazine. She completed the watercolors in two days and two nights.

Shortly after the Kennedys' trip, President Kennedy's father wrote to *Elle* to ask if he could buy the original watercolors for his grandchildren. The same day, Pierre Salinger made the same inquiry on behalf of the president. Duhême decided to offer them as gifts to Caroline. Pierre Salinger came to France to pick up the paintings, and soon thereafter Duhême received an invitation to the White House.

"The president spotted me in the crowd," Duhême recalled for the *New York Herald Tribune*, "and when he heard my name, he grabbed me by the shoulder and shouted across the room, 'Jackie, here is Miss Duhême.'" "He then took me around and showed me his office. He was particularly proud of a collection of seal's teeth engraved by Irish sailors. He also showed me some of Mrs. Kennedy's watercolors, including one of the White House garden." "Mrs. Kennedy has a great deal of talent," Duhême added. "We have about

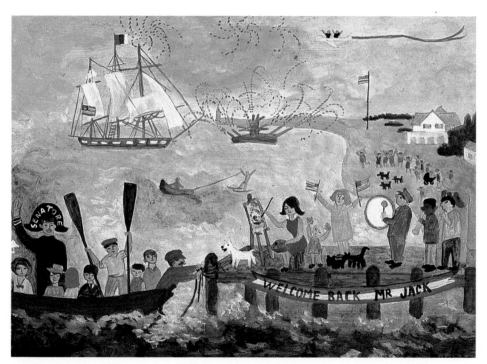

In this painting by Jacqueline Duhême, Mrs. Kennedy is depicted with palette, brush, and easel at the scene of her husband's triumphant return after winning the presidential nomination.

the same style. But she is too shy. She only paints for her family and friends. However, if she had to make a living with her drawings, she could."

Later, Mrs. Kennedy requested that Duhême join her on her goodwill tour of India and Pakistan via Rome. After the paintings from this trip were published in *McCall's*, Mrs. Kennedy wrote Duhême in French, saying that she was overwhelmed by the paintings. She described them as little masterpieces in the style of the 18th-century Mogul miniatures which she loved so much. Duhême was particularly flattered by Jacqueline's wish that the watercolors hold a place of honor at the White House.

Jacqueline Kennedy and Duhême remained friends, with art as a shared passion. Duhême was in charge of supplying all Mrs. Kennedy's paints and brushes from the Left Bank's specialized art shops. In 1962, Duhême was flown from Paris to Cape Cod to give a one-day painting lesson to Mrs. Kennedy.

In 1964 Duhême came to New York and continued her journalistic work, illustrating fashion for *Vogue*. Then she completed the illustrations for two books, *Zazie dans le metro* by Raymond Queneau and *The Talking Machine* by Nobel Prize Winner Miguel Angel Asturias. While in New York she also met and became friends with the sculptor Alexander Calder. Her other assignments have included covering Pope Paul VI's trip to the Holy Land in 1964 and General de Gaulle's trip to South America the same year.

Today Duhême divides her time between Paris and Normandy. Her most recent project was *L'oiseau philosophie*, a children's book written by the philosopher Gilles Deleuze and illustrated by Duhême.

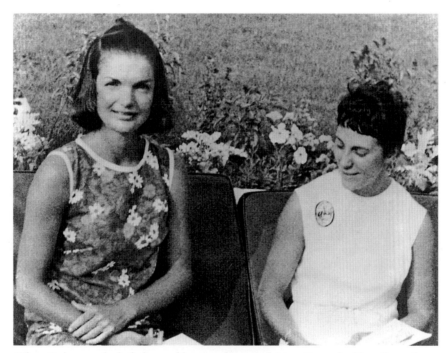

When Duhême asked if she could get a photo with Mrs. Kennedy, Mrs. Kennedy signaled and a guard appeared from out of the bushes nearby to take this photo, at the Kennedy's Cape Cod vacation home, 1962.

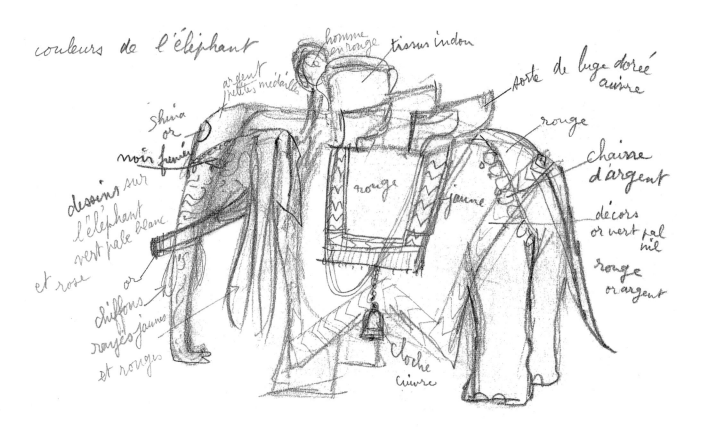

A drawing of an elephant in Jaipur, from Mme Duhême's sketchbook.